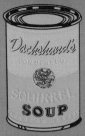
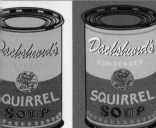
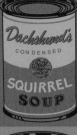
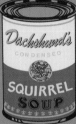
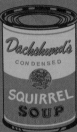

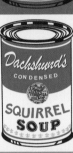

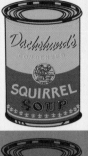

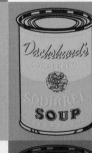
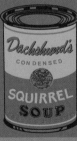
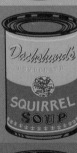
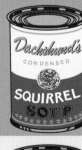
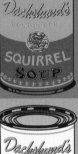

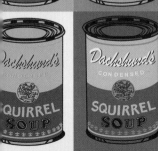
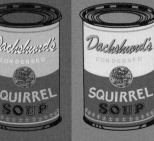
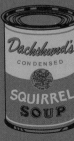
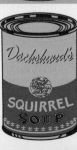

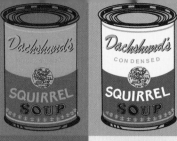

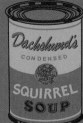
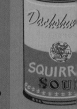
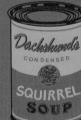
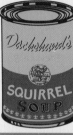
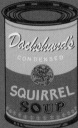

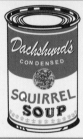
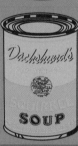
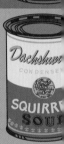
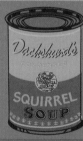
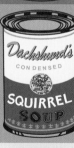
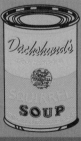
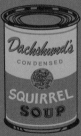

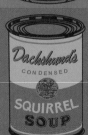
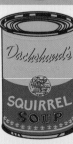
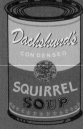
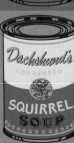
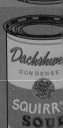

A
DOG'S
GUIDE
TO
ART

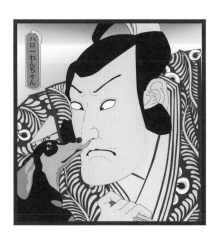

To Andy and Fred
Ned and Henry

First published in the United Kingdom in 2020 by
Portico
43 Great Ormond Street
London
WC1N 3HZ

An imprint of Pavilion Books Company Ltd

ISBN 978-1-911622-53-6

A CIP catalogue record for this book is available
from the British Library.

10 9 8 7 6 5 4 3 2 1

Reproduction by Rival Colour Ltd, UK
Printed and bound by 1010 Printing International,
China

www.pavilionbooks.com

MIX
Paper from
responsible sources
FSC® C016973

A DOG'S GUIDE TO ART

Happy Reading, to you, Lucie & Dave Mum xxx 2023

JOY FITZSIMMONS

PORTICO

INTRODUCTION

For centuries the dog has been a close companion to poets, musicians, writers and artists. Faithful and unjudgemental, they have offered love and inspiration to their owners at times when they might be lost in the creative wilderness.

Many painters have included their favourite hounds in their work – Frida Kahlo, David Hockney, Pierre Bonnard, to name just a few. William Hogarth famously depicted himself with his pug. I try not to be biased but as with styles of art, we each have our breed of choice. To me the dachshund is a design classic: quaint but stylish, loving but enormously willful. The Spitfire of the canine world. But I love all dogs – they are all so very different, each with their own character.

As a dog-owning artist this book contains two of my most favourite things: dogs and art. It was only when I acquired my own dogs, Archie and Doug, that I came up with the idea of placing them in famous paintings. Picasso had done the same. In his reworking of Velazquez's *Las Meninas* he replaced the original hound with his dachshund, Lump, observing the content of the original painting and changing it into something new with another dog in his own inimitable style. When I repeated this process it opened my eyes to all the tiny details of these seemingly well-known paintings, which had gone unnoticed by me before.

The canine additions gave the artworks a whole new direction. Although it introduces humour into serious works of art, it is intended as pure homage to the artists' finest works. In this book I have devised an eventful tumble through a gallery. Our two current dachshunds, Ned and Henry, lead an assortment of eager pals around, spotting their friends and literally getting into art.

By paying homage to some of the old masters of the art world I hope I might show what these hounds can bring into our hectic lives: mayhem and joy.

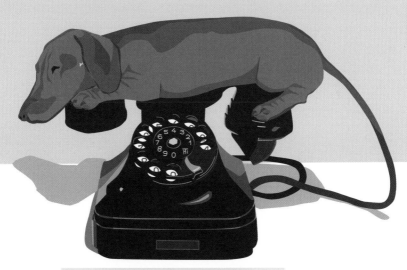

NEDSTER TELEPHONE

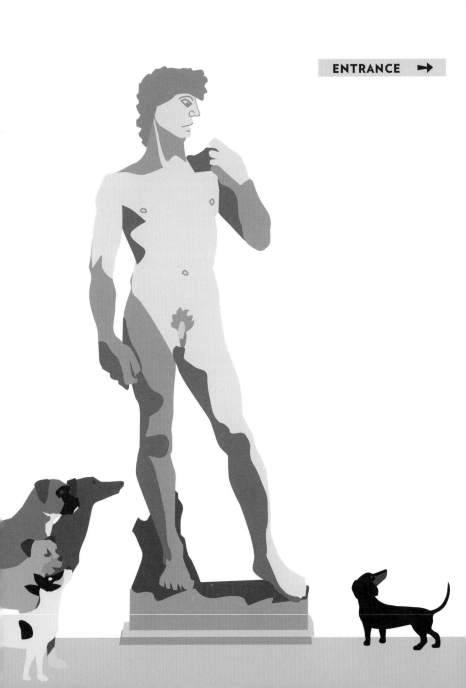

ENTRANCE →

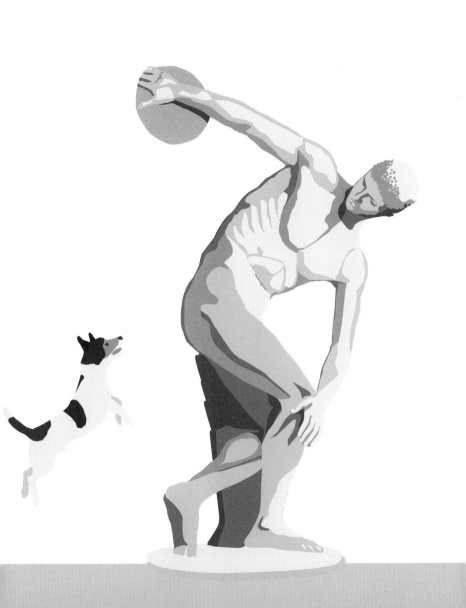

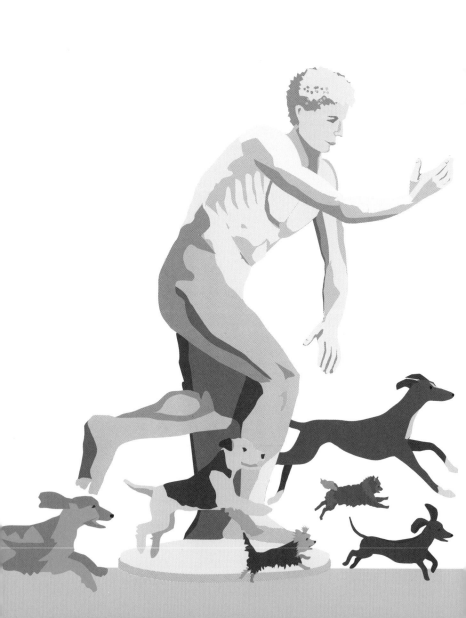

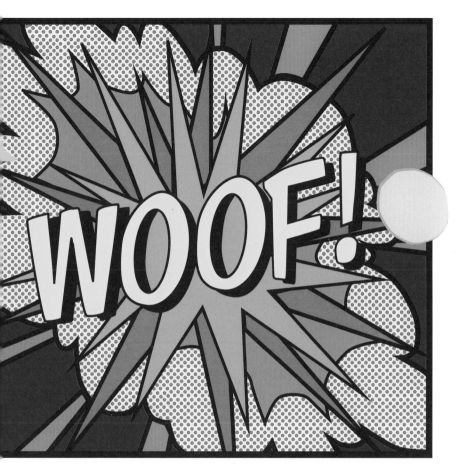

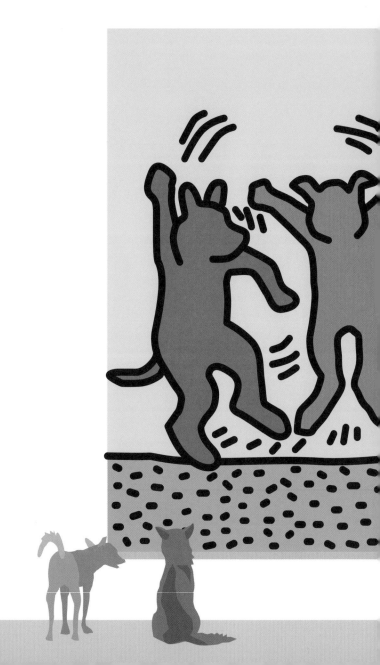

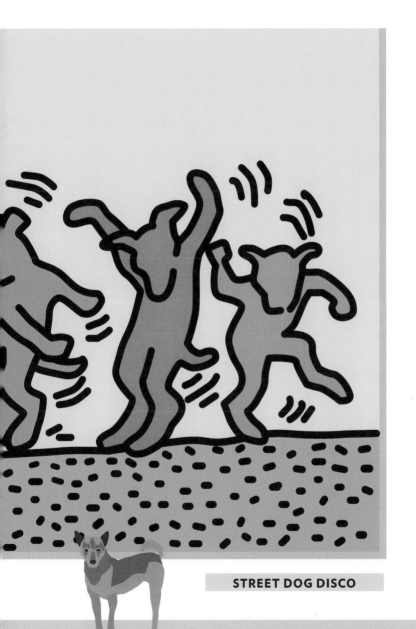

STREET DOG DISCO

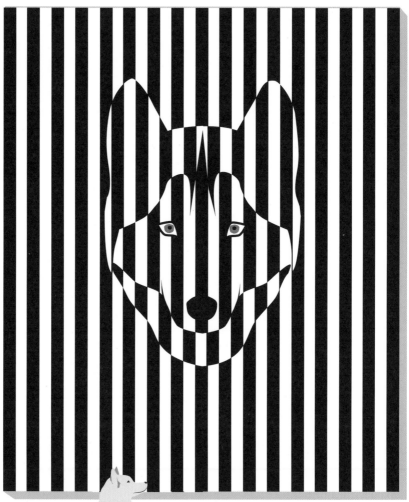

IN STRIPED CLOTHING

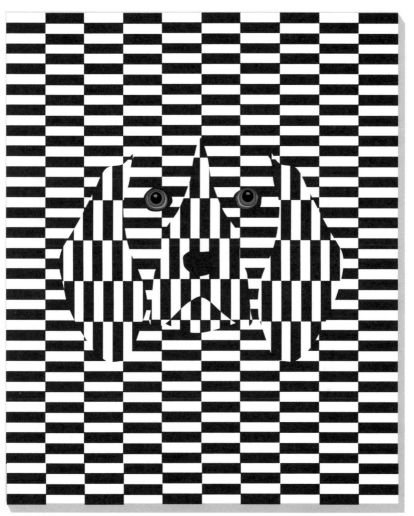

POP GOES THE BEAGLE

IN THE PICTURE

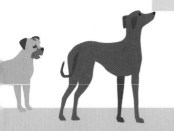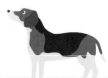

DRIVING TO THE PARK

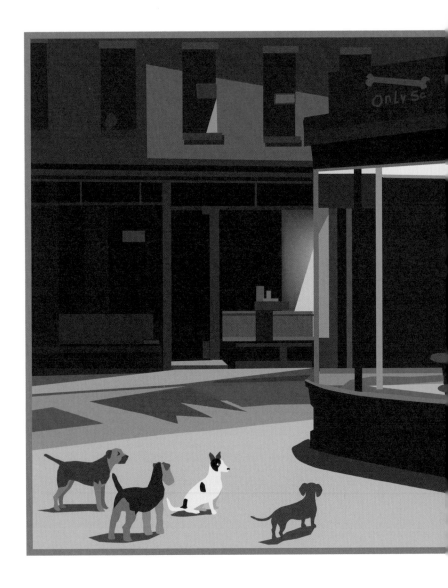

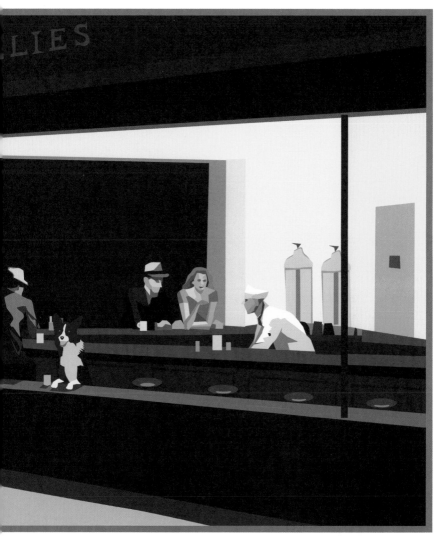

 NIGHTHOUNDS

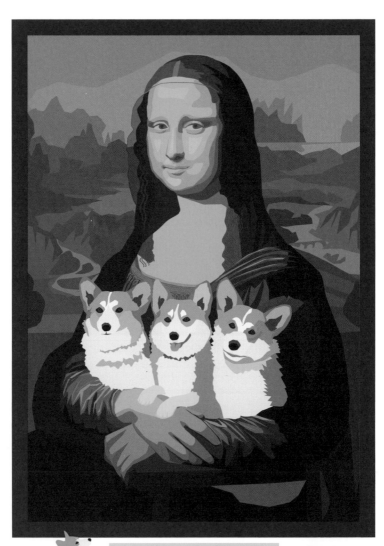

LA GIACORGA

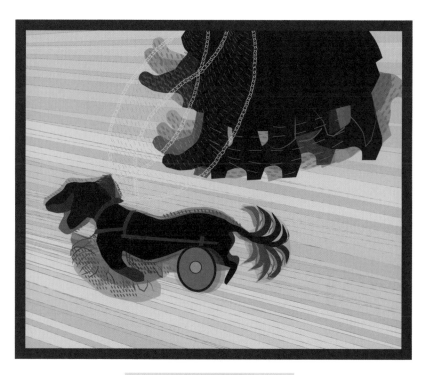

HOT WHEELS

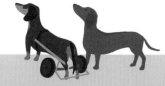

MRS MIRÓ'S NAUGHTY DOGS

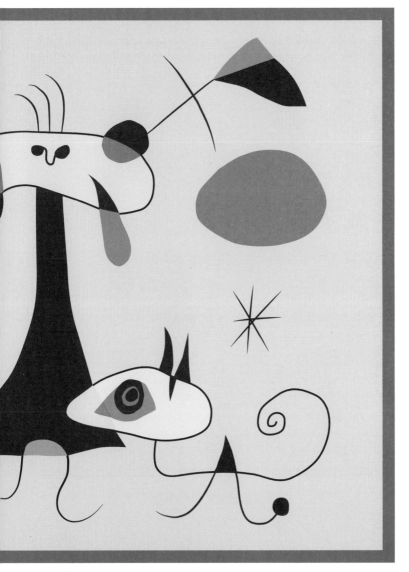

PAWTRAIT

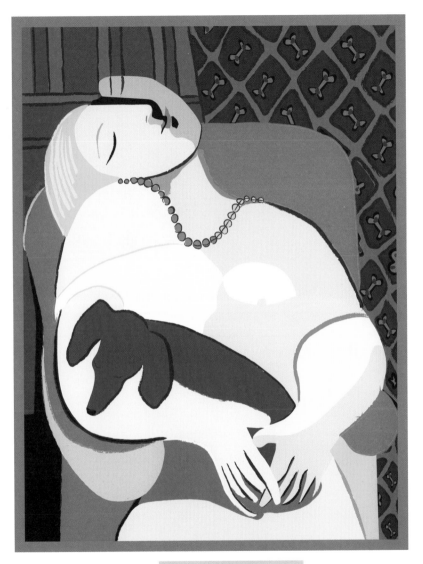

DREAMS

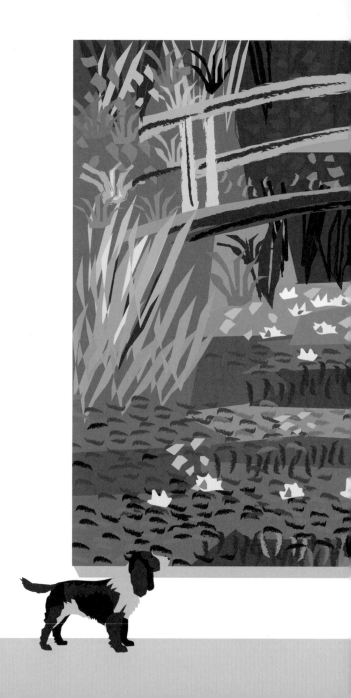

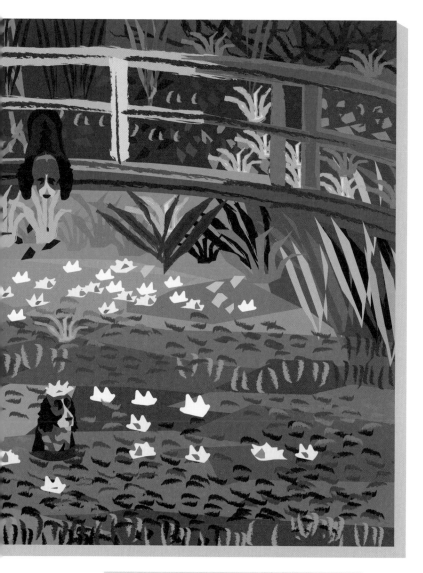

WE'RE IN THE MONET

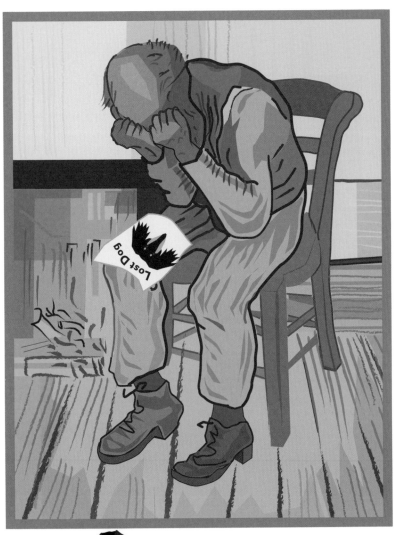

DINNER FOR ONE

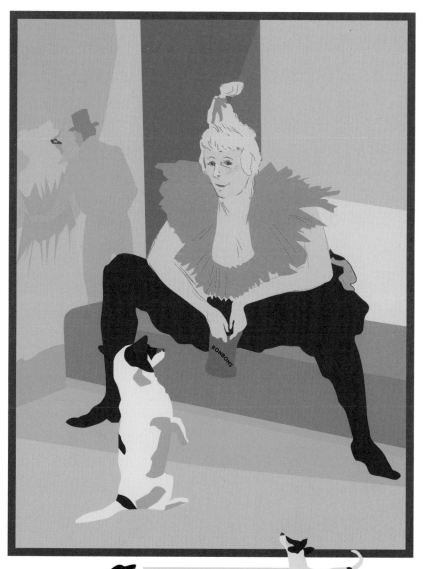

DINNER FOR TWO

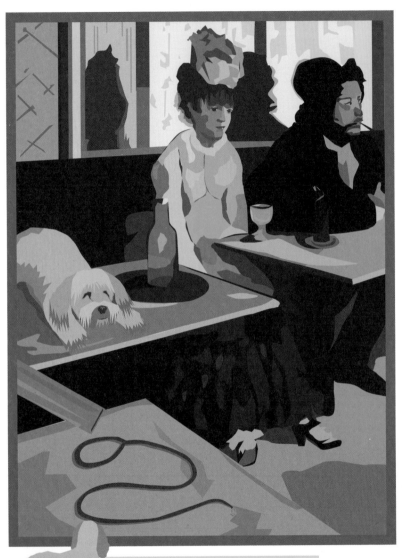

ABSINTHE WITHOUT LEAD

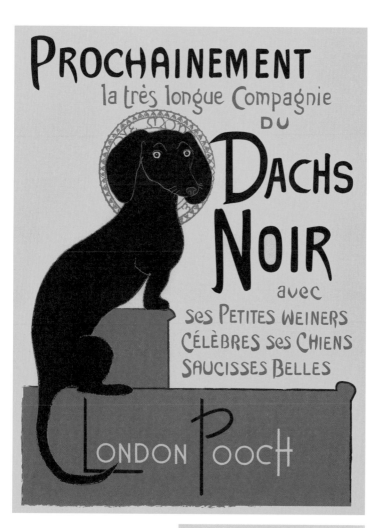

DACHS NOIR

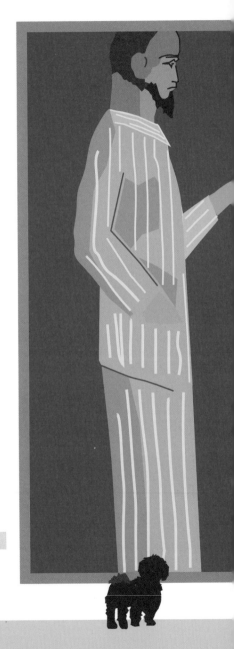

SURELY NOT OUR LITTLE DEYZE

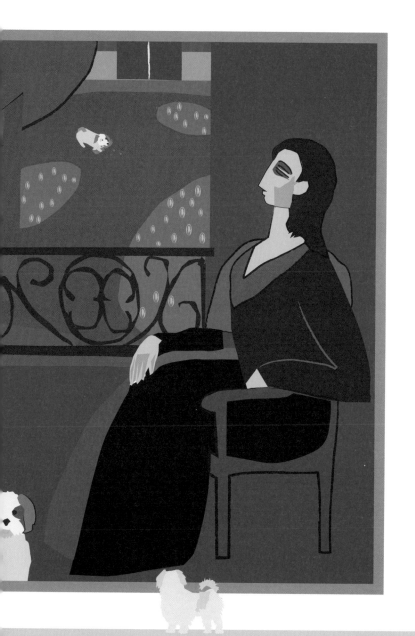

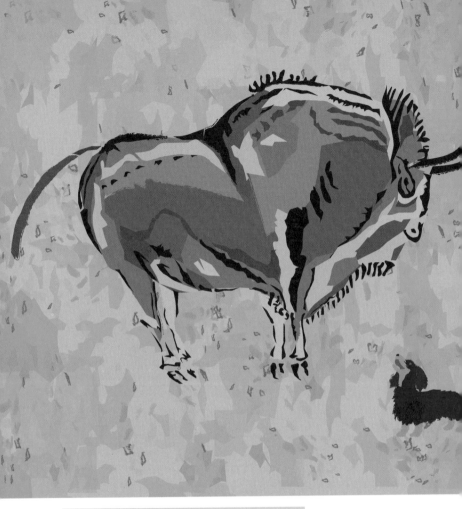

HAPPY HUNTING GROUND

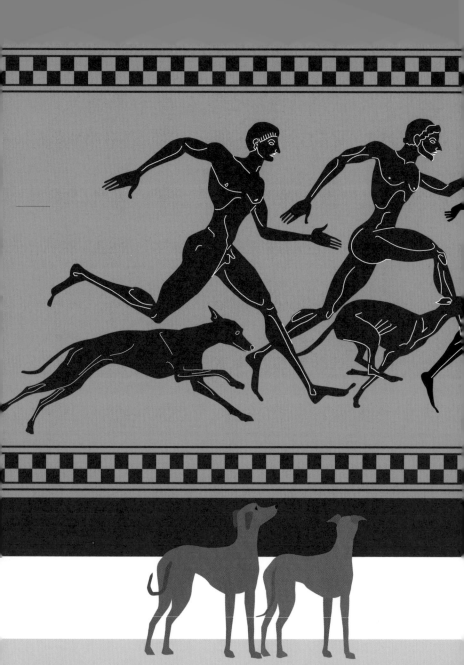

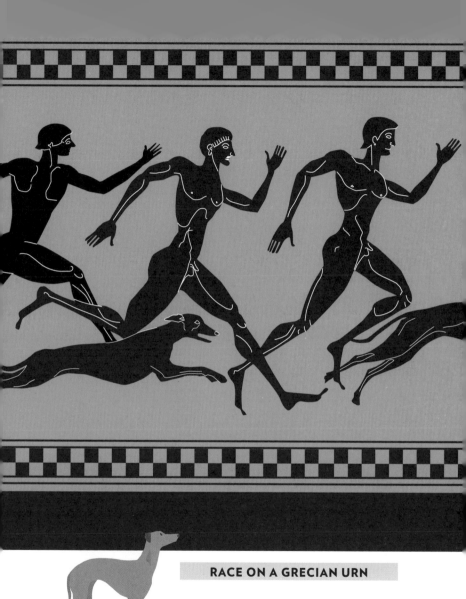

RACE ON A GRECIAN URN

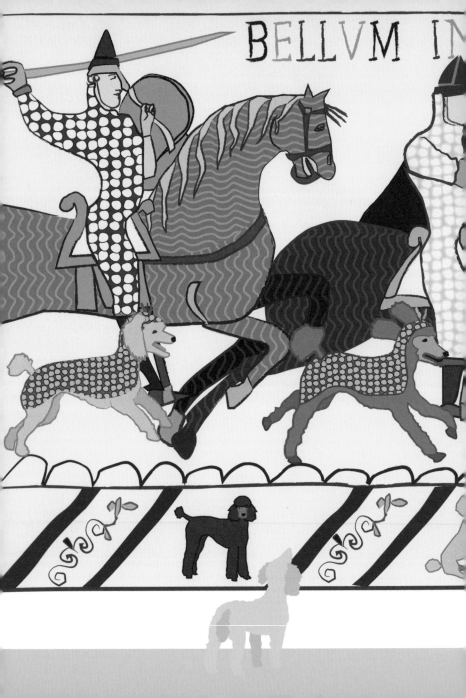

BELLVM IN

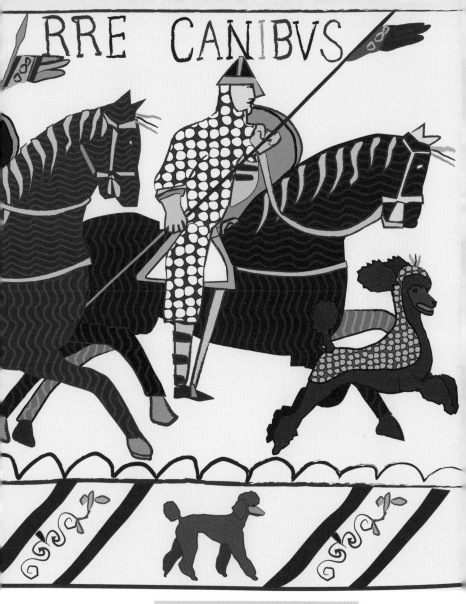

THE DOGS OF WAR

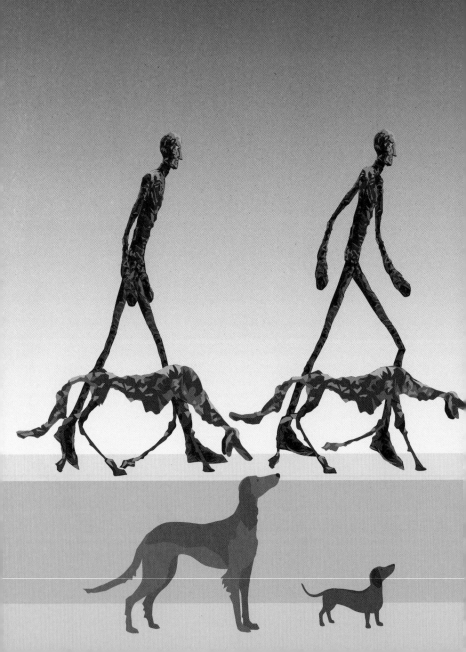

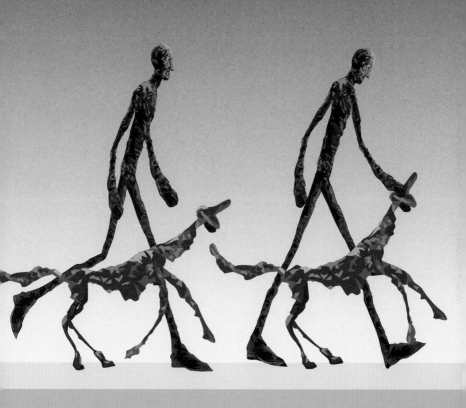

WALKING THE DOG

POST-HANGDOG EXPRESSIONISM

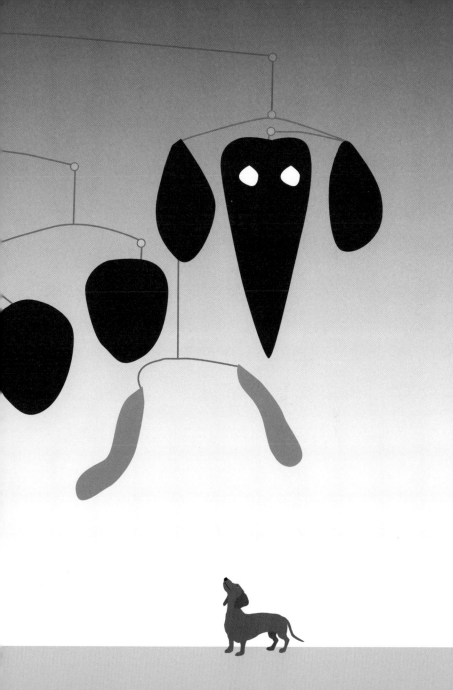

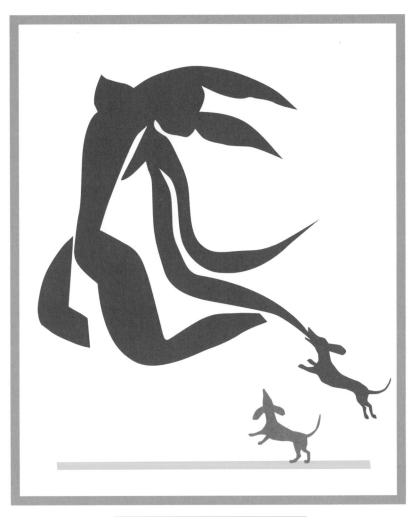

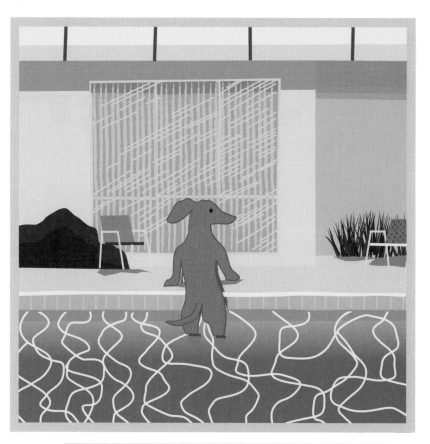

NED GETTING OUT OF HENRY'S POOL

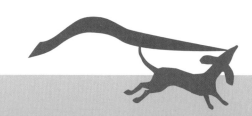

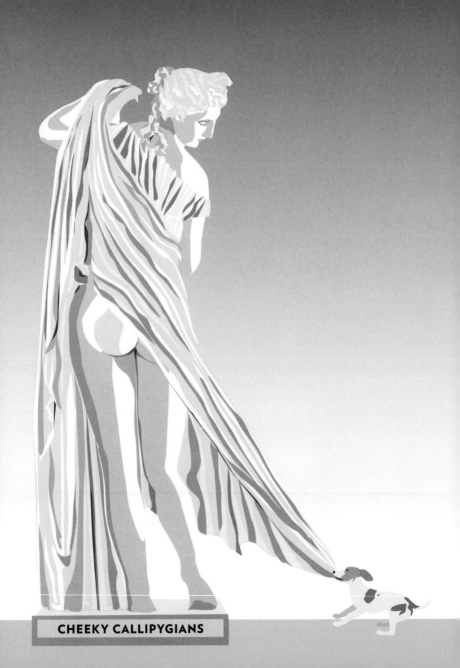

CHEEKY CALLIPYGIANS

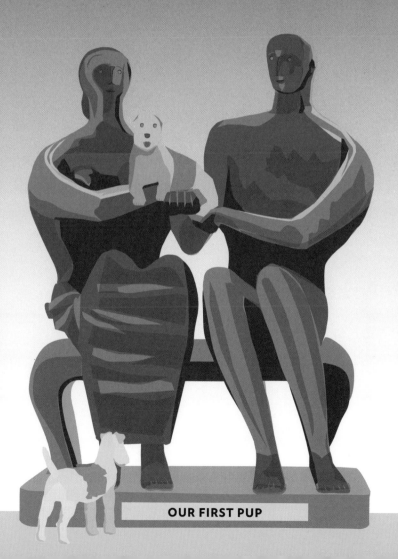

OUR FIRST PUP

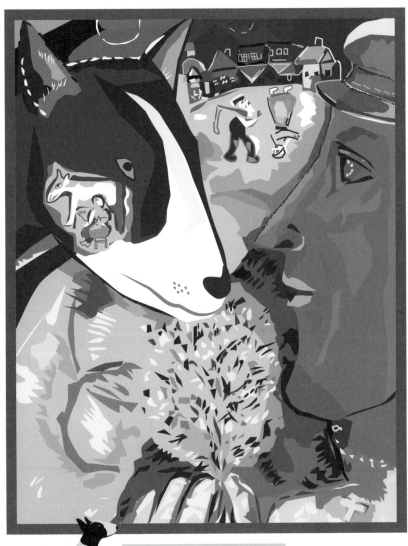

BULL NOSED

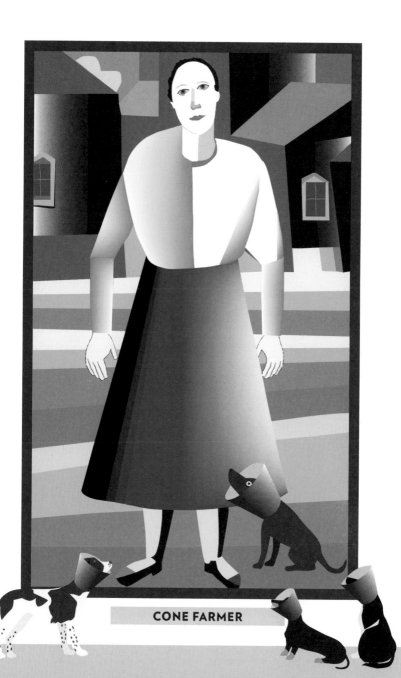

CONE FARMER

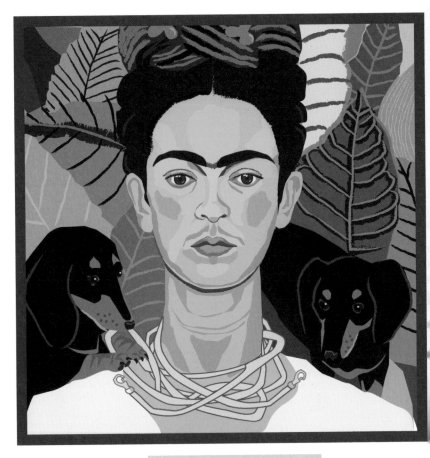

FRIDA'S COLLAR

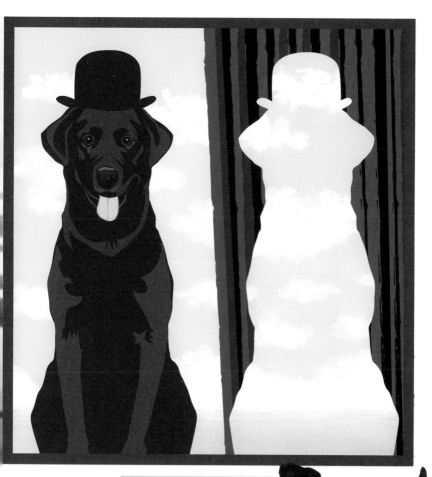

RENÉ'S HAT

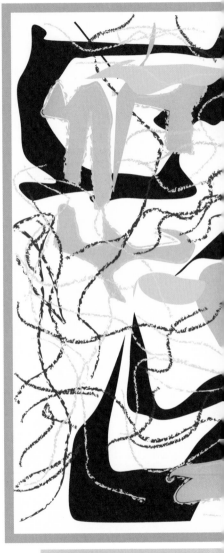

DACHSHUND POLLOCK

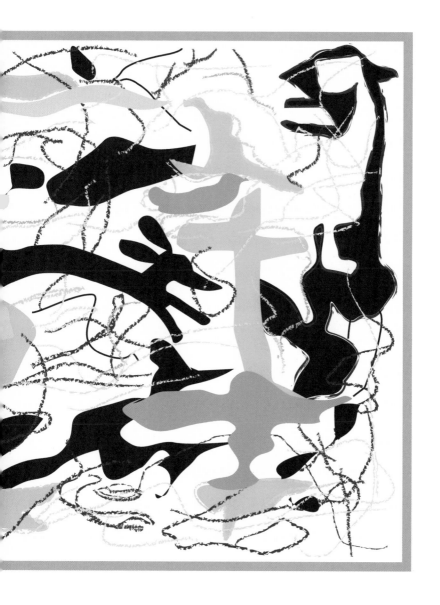

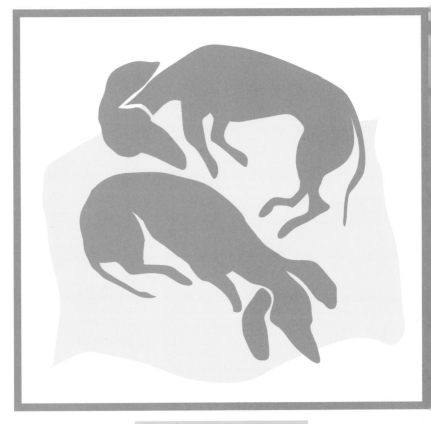

DACHS BLEU II

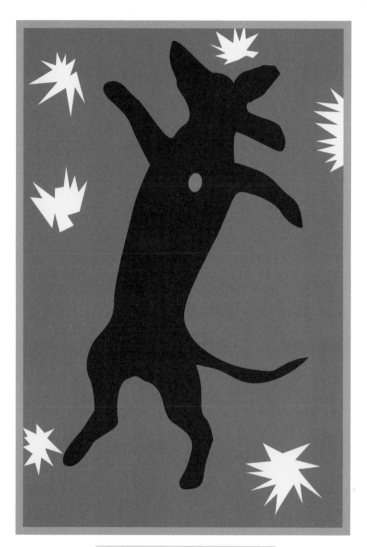

THE FALL OF HENRY

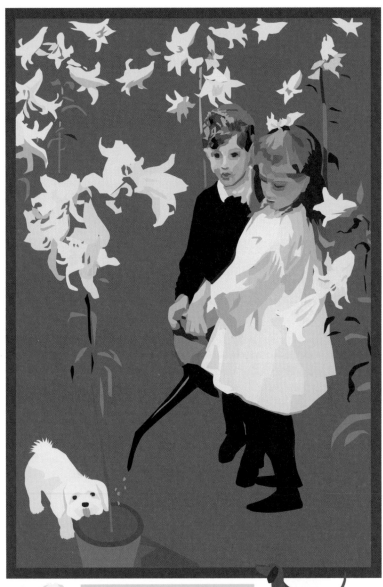

NATURE NURTURE

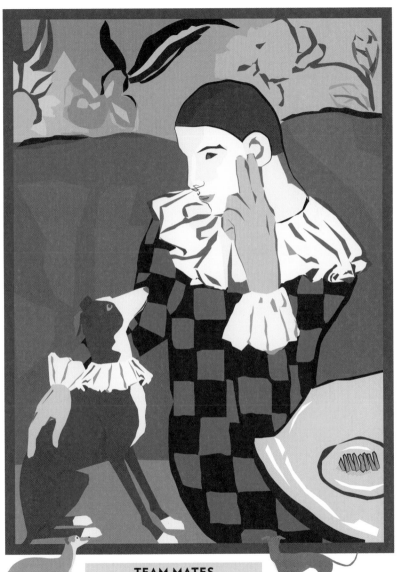

TEAM MATES

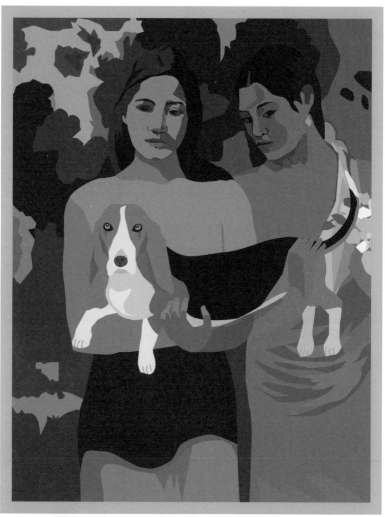

 UNTYPICAL TROPICAL TRIO

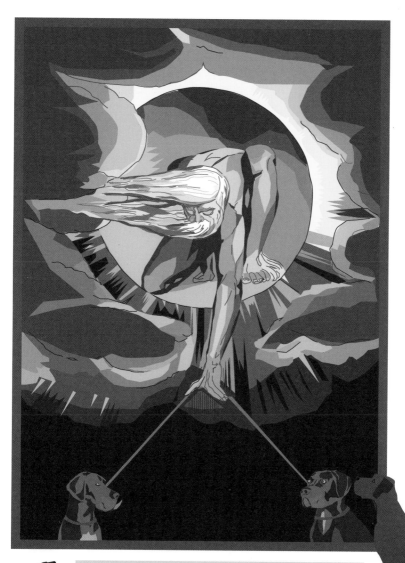

PUPPY TRAINING FOR LITTLE CAIN & ABEL

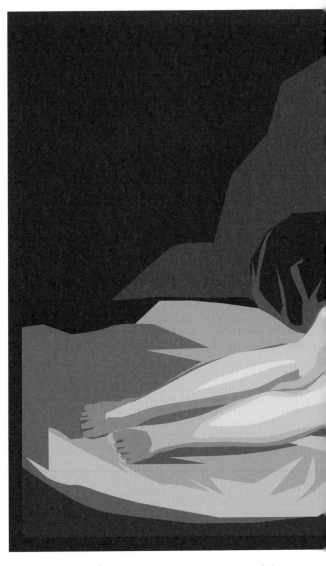

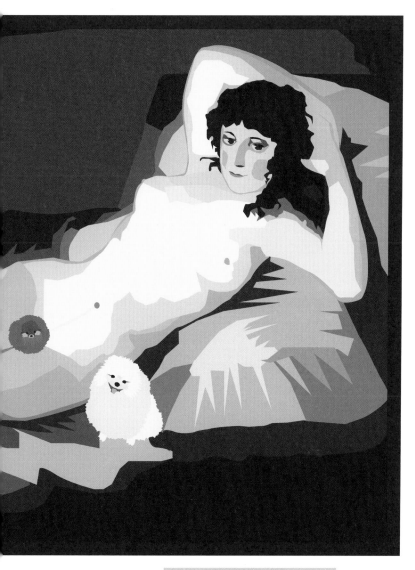

POM-POMS

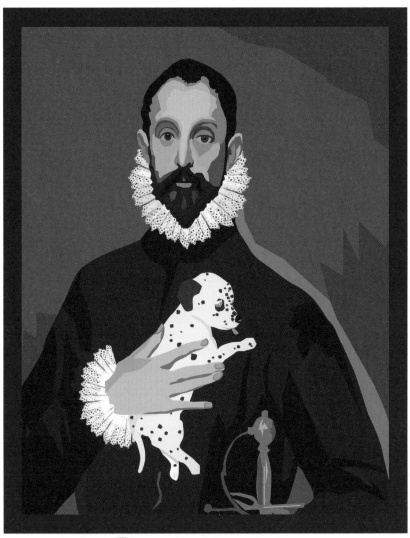

EL GRESCUE

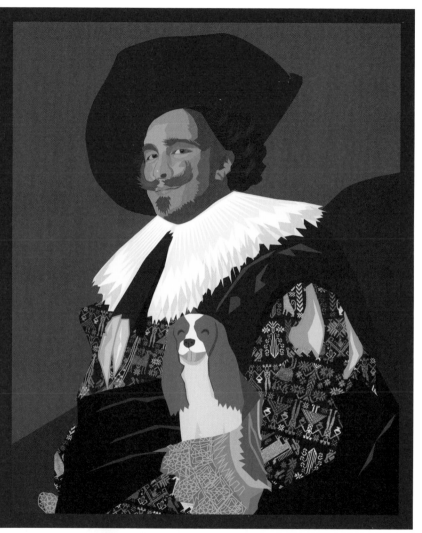

LAUGHING CAVALIERS

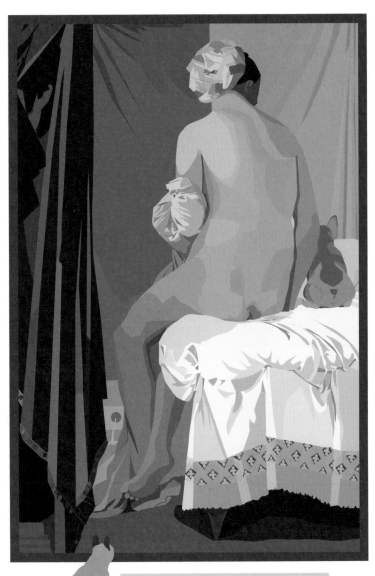

TWO BATHERS

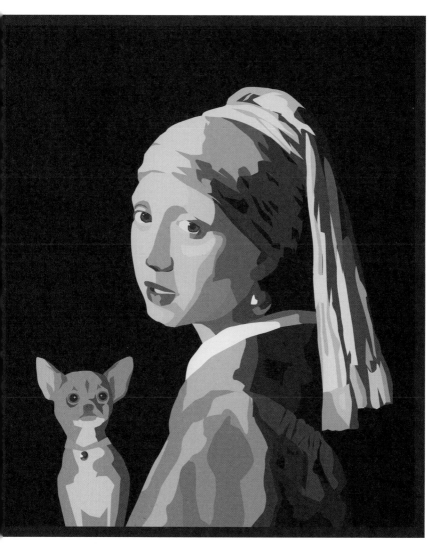
 GIRLS WITH PEARLS

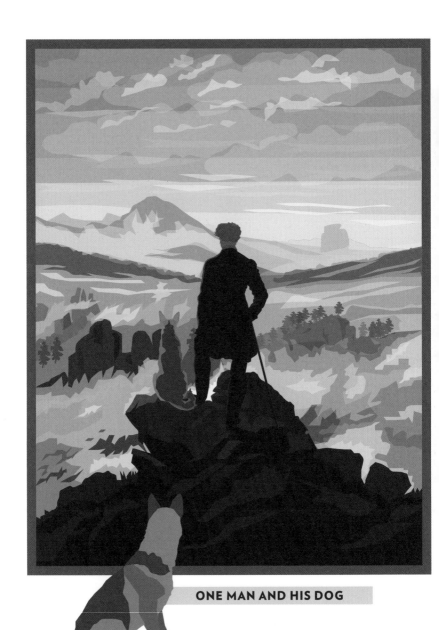

ONE MAN AND HIS DOG

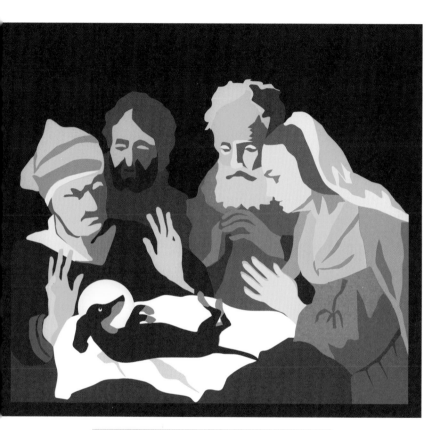

ADORATION OF THE DACHSI

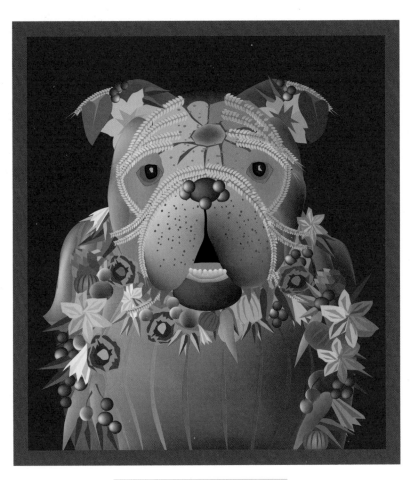

ARCIMBULLDOG

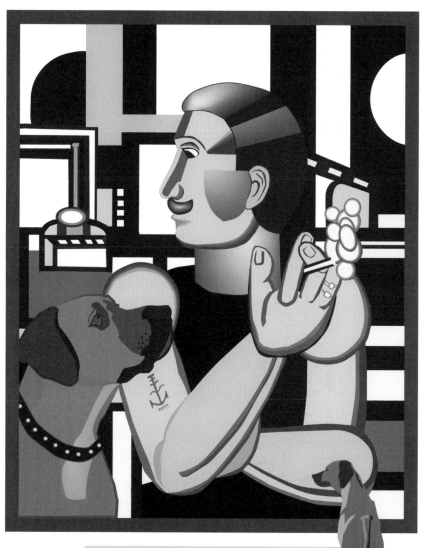

CUSTOM-BUILT RIDGEBACK

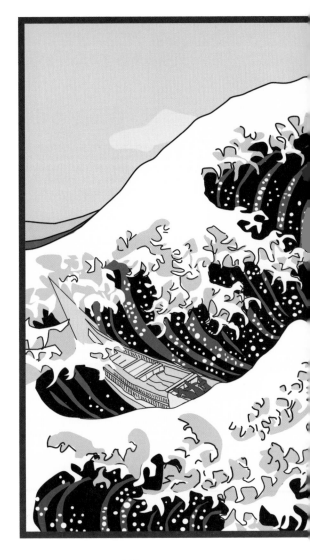

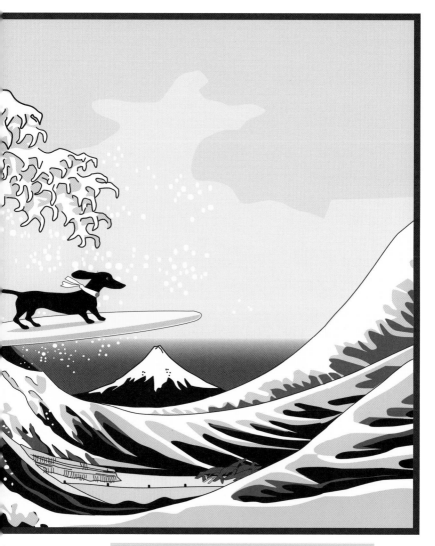

CATCH THE GREAT WAVE

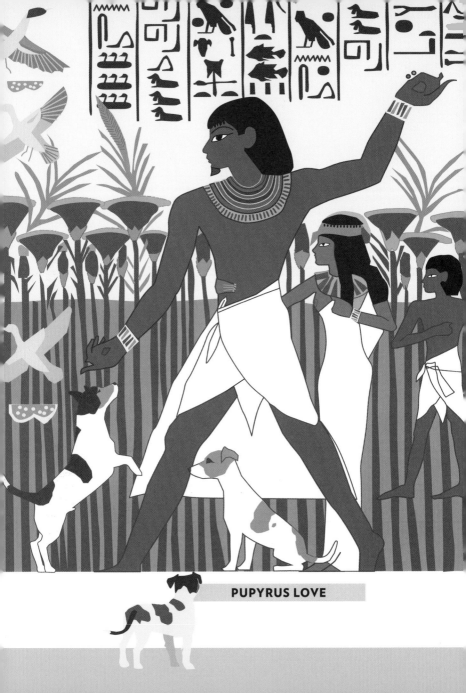

PUPYRUS LOVE

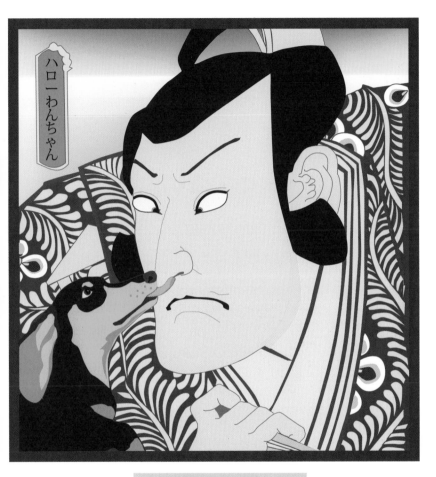

ハロ一わんちゃん

HELLO PUPPY

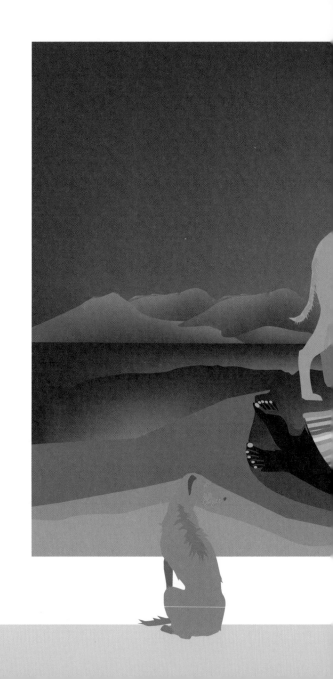

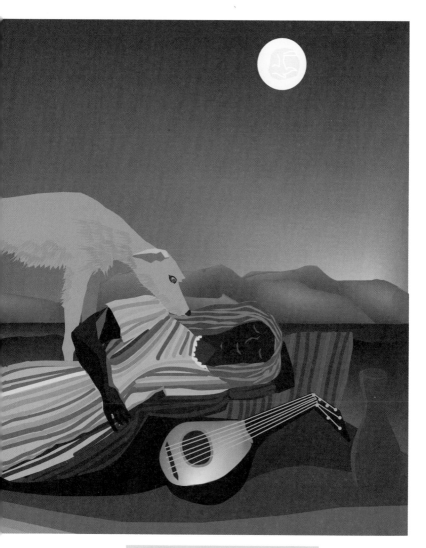

LET SLEEPING FOLK LIE

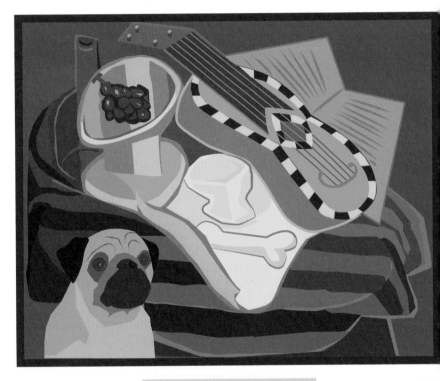

STILL PUG LIFE

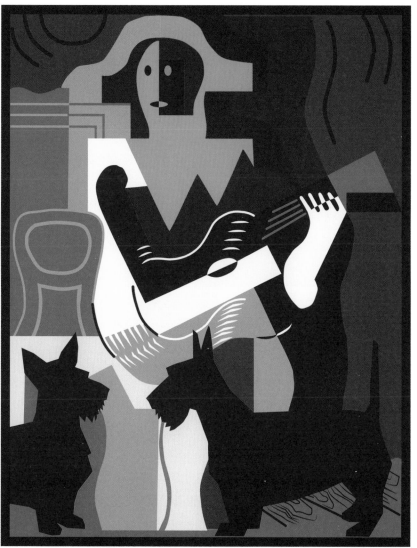

 JUAN HARLEQUIN TWO SCOTTIES

MC DACHSER

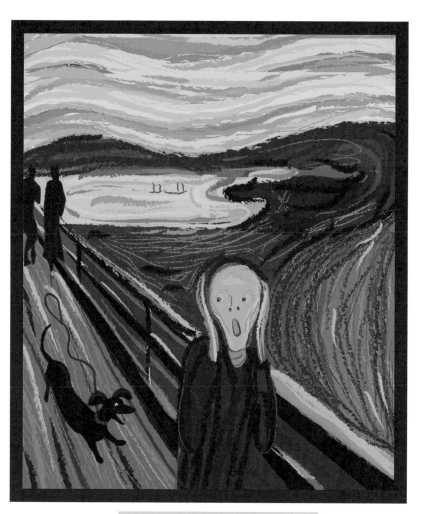

DACHSMUNCH SCREAM

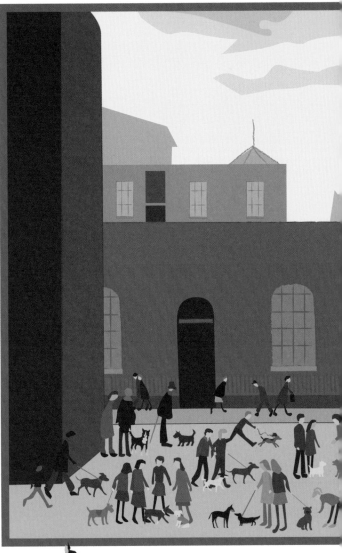

MILLING AROUND

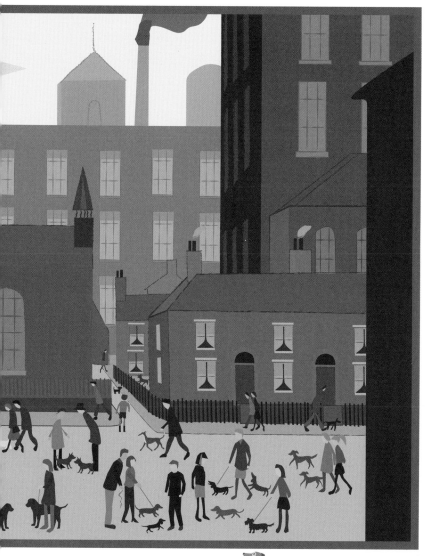

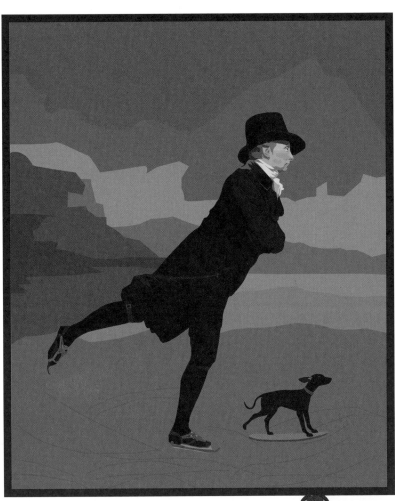

REVEREND'S PUPPY

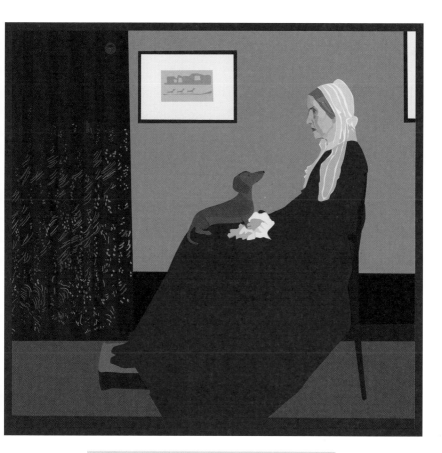

MOTHER'S DACHSHUND

HEAD IN CLOUDS

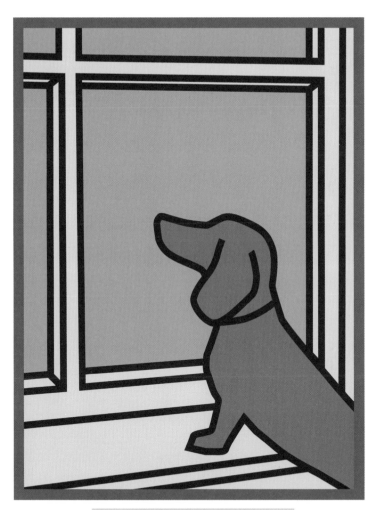

SQUIRREL WATCH

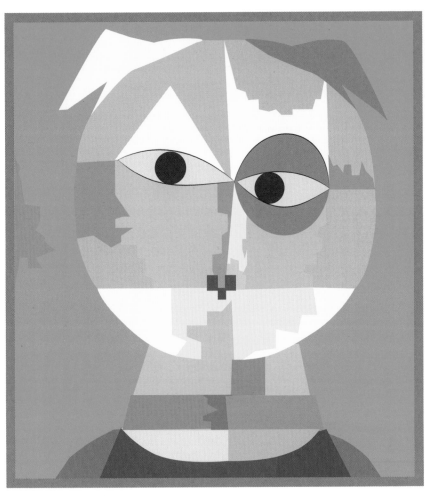

 CROSS-EYED PATCH

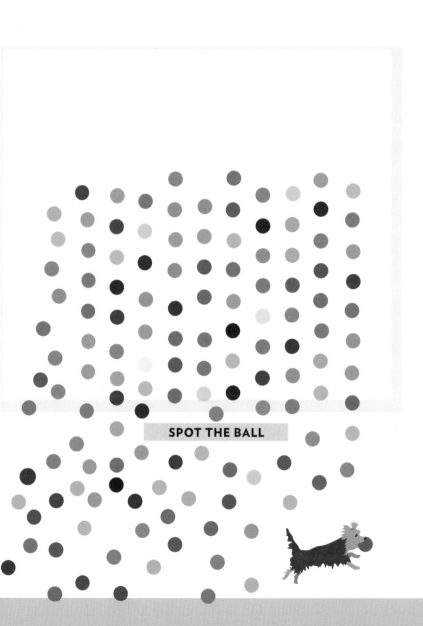

SPOT THE BALL

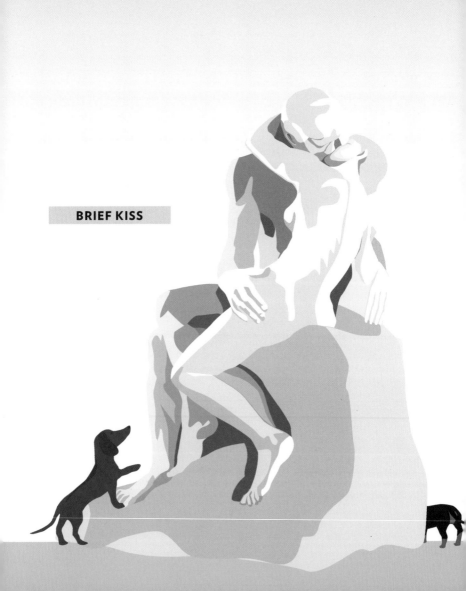

BRIEF KISS

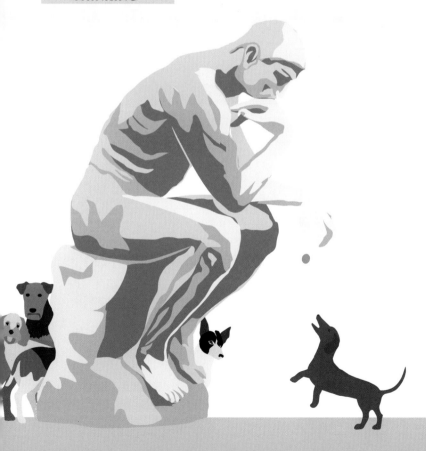

THINKING

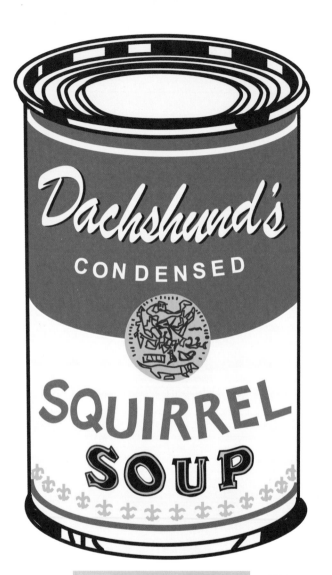

Dachshund's

CONDENSED

SQUIRREL SOUP

SQUIRREL SOUP

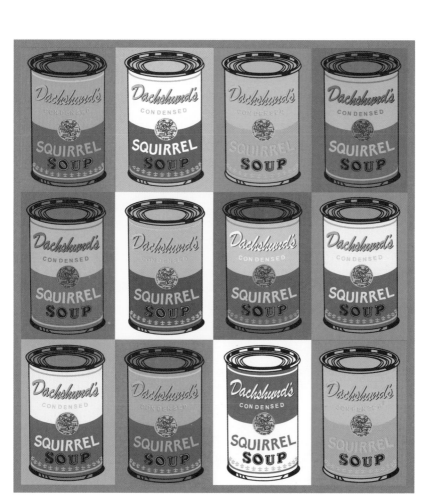

MORE SQUIRREL SOUP

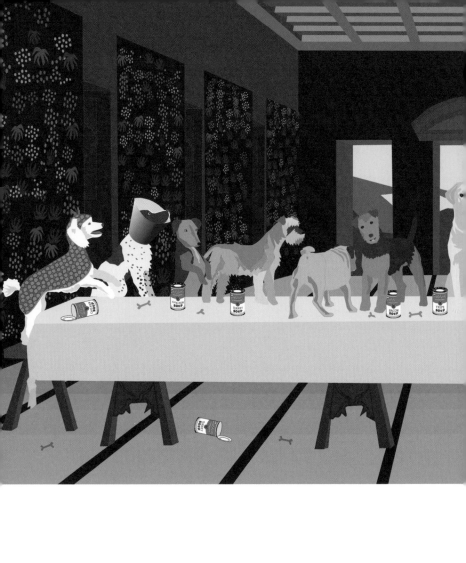

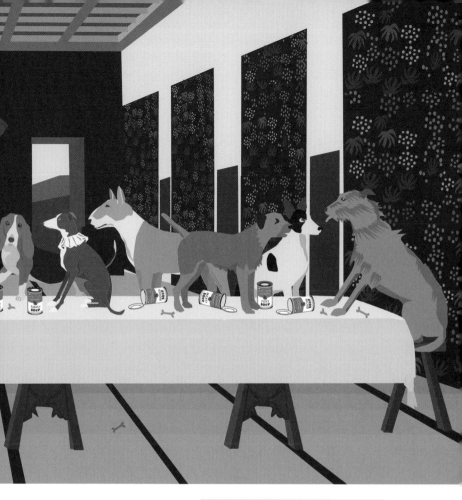

AT LAST SUPPER

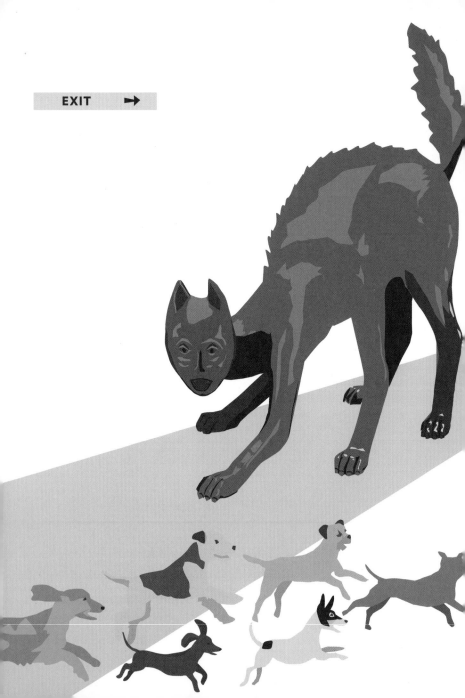

EXIT →

IN SINCERE HOMAGE TO THESE WORKS:

Page 2/3
The Girl with the Balloons
Banksy, 2005
Palestinian side of the West Bank wall

Page 5
Lobster Telephone
Salvador Dali, 1936
Dali Universe, London; Museum für
Kommunikation Frankfurt; Edward
James Foundation, West Sussex;
National Gallery of Australia,
Canberra and Tate Modern, London

Page 6
David
Michaelangelo, 1501–1504
Galleria dell'Accademia, Florence
Plaster cast at the V&A, London

Page 7
The Discobolus of Myron
5th century BC
National Museum of Rome

Page 8/9
Inspired by *The Discobolus of Myron*,
as above
Inspired by Roy Lichtenstein

Page 10/11
Untitled (Dance)
Keith Haring, 1987

Page 12/13
Inspired by Bridget Riley

Page 14
Inspired by Piet Mondrian

Page 15
In the Car
Roy Lichtenstein, 1963
Scottish National Gallery of Modern
Art, Edinburgh

Page 16 /17
Nighthawks
Edward Hopper, 1942
Art Institute of Chicago

Page 18
Mona Lisa
Leonardo da Vinci, 1503
Musée du Louvre, Paris

Page 19
Dynamism of a Dog on a Leash
Giacomo Balla, 1912
Albright–Knox Art Gallery, Buffalo
New York

Page 20/21
Figure, Dog, Birds
Joan Miró, 1946
Solomon R. Guggenheim Museum,
New York

Page 22
Portrait of Françoise Gilot
line drawing
Pablo Picasso, 1946

Page 23
The Dream
Pablo Picasso, 1932
Private collection Steven A. Cohen

Page 24/25
Water Lilies and Japanese Bridge
Claude Monet, 1899
Princeton University Art Museum,
New Jersey

Page 26
*Sorrowing Old Man (At Eternity's
Gate)*
Vincent van Gogh, 1890
Kröller-Müller Museum,
Otterlo, NL

Page 27
The Seated Clowness
Henri de Toulouse-Lautrec, 1896
National Gallery of Art, Washington
DC

Page 28
The Absinthe Drinker
Edgar Degas, 1875–1876
Musée d'Orsay, Paris

Page 29
Le Chat Noir poster
Théophile Steinlen, 1896
Museu Nacional d'Art de Catalunya,
Barcelona

Page 30/31
The Conversation
Henri Matisse 1908–1912
State Hermitage Museum,
St Petersburg

Page 32/33
Altamira cave painting
c.15,000 BC
Altamira, Spain

Page 34/35
Inspired by Greek vase with runners
at the Panathenaic Games, c.530 BC

Page 36/37
The Bayeux Tapestry
Bayeux, Normandy
11th century

Page 38/39
Dog
Alberto Giacometti, 1951
Museum of Modern Art, New York
and *The Walking Man*
Alberto Giacometti, 1960

Carnegie Museum of Art, Pittsburgh;
Private collection of Lily Safra;
Fondation Maeght, Saint-Paul;
Albright-Knox Art Gallery,
Buffalo; Louisiana Museum of
Modern Art, Humlebæk; Tehran
Museum of Contemporary Arts,
Tehran

Page 40/41
Inspired by Alexander Calder

Page 42
Blue Nude with Hair in the Wind
Henri Matisse, 1952

Page 43
Peter Getting out of Nick's Pool
David Hockney, 1966
Walker Art Gallery, Liverpool

Page 44
Callipygian Venus
Artist unknown, 1st or 2nd century
BC
National Archaeological Museum,
Naples

Page 45
Family Group
Henry Moore, 1950
Barclay Secondary School,
Stevenage; Museum of Modern Art,
New York; Tate Gallery, London

Page 46
I and the Village
Marc Chagall, 1911
Museum of Modern Art, New York

Page 47
Girl in the Country
Kazimir Malevich, 1929
The Russian Museum, St.Petersburg

Page 48
*Self-Portrait with Thorn Necklace
and Hummingbird*
Frida Kahlo, 1940
Harry Ransom Center, Austin, Texas

Page 49
Décalcomania
René Magritte, 1966

Page 50/51
Number 12A Yellow Grey Black
Jackson Pollock, 1948

Page 52
Inspired by Henri Matisse

Page 53
Icarus
plate VIII from *Jazz*
Henri Matisse, 1947

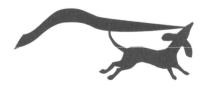

WITH MANY THANKS TO THE FOLLOWING DOGS:

2/3
Spider (Lurcher), Rooney (Border Terrier), Ed (Pug), Bea (Beagle), Reggie (Schnauzer), Stringer Bell (Cojack), Ned & Henry (Dachshunds)

4/5 NEDSTER TELEPHONE
Ned

6/7 ENTRANCE
Bronte (Boxer), Spider, Rooney, Stringer Bell, Henry & Harvey

8/9 WOOF!
Clementine (Spaniel), Ralphie (Lakeland Terrier), Spider, Leopold (Pomeranian), Prudence (Yorkshire Terrier), Rooney, Stringer Bell, Ruby (Staffordshire Bull Terrier), Ned & Henry

10/11 STREET DOG DISCO
Pecan (Three-legged rescue) & street dogs everywhere

12 IN STRIPED COTHING
Brenin (Siberian Husky)

13 POP GOES THE BEAGLE
Bea

14 IN THE PICTURE
Rooney, Spider, Bea, Nelson (Portuguese Water Spaniel), Wallace (Cockerpoo), Henry, Bronte (Boxer), Stringer Bell, Simon (Pug),

15 DRIVING TO THE PARK
Larry (Labrador)

16/17 NIGHTHOUNDS
Rooney, Dulcie (Welsh Terrier), Stringer Bell, Ned, Mollie (Collie–Spaniel Cross)

18 LA GIACORGA
Rex, Willow & Holly (Corgis)
Candy (Dorgi)

19 HOT WHEELS
Henry (Red Dachshund) & Jonny (Dachshund on Wheels)

20/21 MRS MIRÓ'S NAUGHTY DOGS
Miró dogs and Ned

22 PAWTRAIT
Ruby Keeler (Dachshund)

23 DREAMS
Ned & Henry

24/25 WE'RE IN THE MONET
Ella & Sadie (Blue Roan Cocker Spaniels)

26 DINNER FOR ONE
Mitzi (Long-haired Dachshund)

27 DINNER FOR TWO
Stringer Bell & Henry

28 ABSINTHE WITHOUT LEAD
Wallace (Cockapoo)

29 DACHS NOIR
Henry

30/31 SURELY NOT OUR LITTLE DEYZE
Deyze & pal (Lhasa Apso)

32/33 HAPPY HUNTING GROUND
Dhillon (Long-haired Dachshund), Stephen (Dachshund), Midge (Flat-coated Retriever), Bracken (Spaniel), Dolly, Moppet & Tiggy (Wire-haired Dachshunds) Millie (Chorkie) & Mabel (Dachshund)

34/35 RACE ON A GRECIAN URN
Sparrow (Lurcher), Spider & Decca (Whippet)

36/37 THE DOGS OF WAR
Keechee (Poodle)

38/39 WALKING THE DOG
Ned & Saluki

40/41 POST-HANGDOG EXPRESSIONISM
Henry & Badger (Standard Dachshund)

42 AFTER MATISSE
Roma Bella (Dachshund)

43 NED GETTING OUT OF HENRY'S POOL
Matisse-style Dachshund

44 CHEEKY CALLIPYGIANS
Ellie (Jack Russell)

45 OUR FIRST PUP
Ralphie (Lakeland Terrier)

46 BULLNOSED
Martha (Miniature Bull Terrier)

47 CONE ENVY
Alfie (Springer Spaniel), Mollie & Henry

48 FRIDA'S COLLAR
Archie & Doug (Dachshunds) & Frida's monkey & cat

49 RENÉ'S HAT
June & Ted (Labradors)

50/51 DACHSHUND POLLOCK
Ned

52 DACHS BLEU II
Huxley & Rosa (Long-haired Dachshunds)

53 FALL OF HENRY
Henry

54 TO MAKE IT GROW
Henry (Maltese) & Ned

55 TEAM MATES
Yoko (Italian Greyhound) & Decca

56 UNTYPICAL TROPICAL TRIO
Otis (Bassett Hound)

57 PUPPY TRAINING FOR LITTLE CAIN & ABEL
Grace (Great Dane) & Keanu (French Bulldog–Spaniel Cross)

58/59 POM-POM
Naala & Leopold (Pomeranians)

60 EL GRESCUE
Daisy (Dalmation puppy)

61 LAUGHING CAVALIERS
Hattie & Ivy (Cavalier King Charles Spaniel)

62 TWO BATHERS
Zacky (French Bulldog)

63 GIRLS WITH PEARLS
Jimichew (Chihuahua) & pal & Henry

64 ONE MAN AND HIS DOG
Noah (Alsatian)

65 ADORATION OF THE DACHSI
Buckley the wonder dog (Dachshund) and the gang

66 ARCIMBULLDOG
Mr Brown Bear (Bulldog)

67 CUSTOM-BUILT RIDGEBACK
Raffa & Reggie (Rhodesian Ridgebacks)

68/69 CATCHING THE GREAT WAVE
Wilf (Dachshund)

70 PUPYRUS LOVE
Harvey, Ellie & Holly (Jack Russells)

71 HELLO PUPPY
Henry

72/73 LET SLEEPING FOLK LIE
Tiger (Lurcher)

74 STILL PUG LIFE
Simon, Bingo & Rollie (Pugs)

75 JUAN HARLEQUIN TWO SCOTTIES
Phoebe & Zoe (Scottish Terriers)

A NOTE FROM THE AUTHOR

Dachshunds have been appearing in my redrawn
works of the masters for the last two decades. They
can be found in galleries, shops and museums and on
my London Pooch website www.londonpooch.co.uk.

Here in the book the Dachshunds have graciously
allowed me to invite some of the other dogs we
encounter on our walks.

My thanks go to Katie Cowan and Helen Lewis
for agreeing to publish this book. Juliet Bawden for
spurring me to action. Jean Hill of Dulwich Picture
Gallery and Vincent Westbrook for their enthusiasm.
Carolyn Hart and Emma Hagestadt for vital lunches
at Llewelyn's, Herne Hill. Stephen Wyatt for the lively
pun meetings. And lastly to Andy for great support
and putting up with me for the duration.

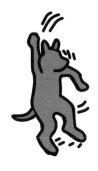

Especial thanks to Ned and Henry, Bruno, Nancy
and Ronnie, the Dachshund Mafia.

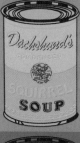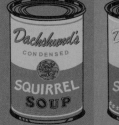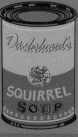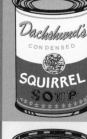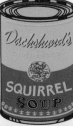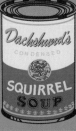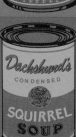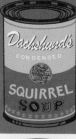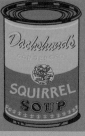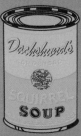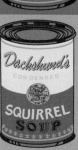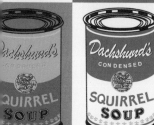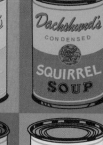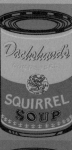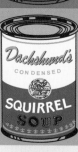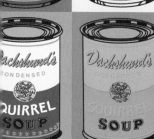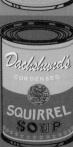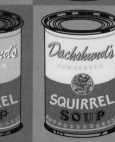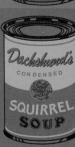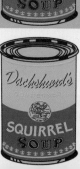

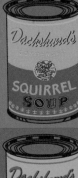
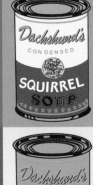
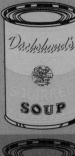
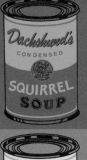
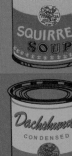
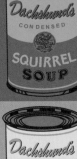
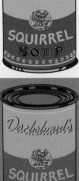
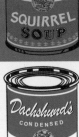
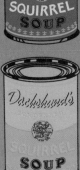
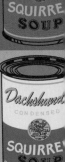
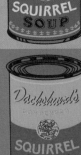
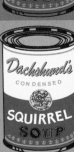
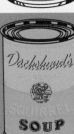
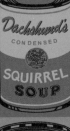
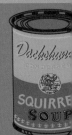
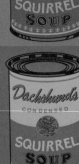
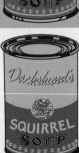
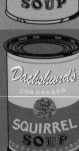
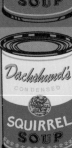
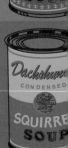